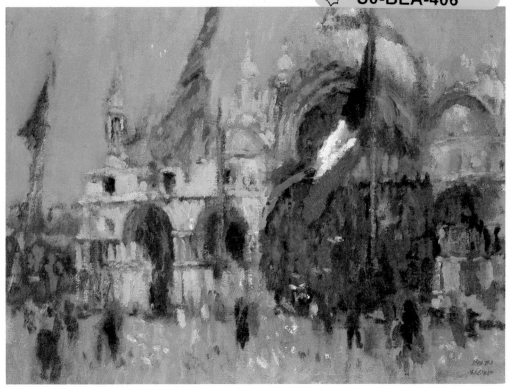

Keith Ward Paints
IMPRESSIONISM

An Approach To
Impressionistic Painting.

Walter Foster Publishing, Inc.
430 West Sixth Street, Tustin, CA 92680-9990

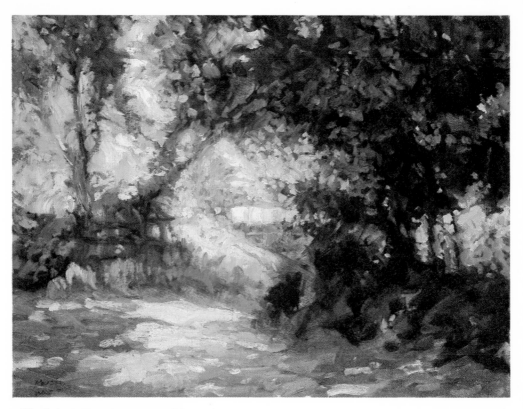

CONTENTS

WHAT IS IMPRESSIONISM?

Great art was created during all periods of history and the art of each period was an expression of the customs and mores of the time. For centuries it was the fashion for artists to paint allegorical or story-telling pictures, laboriously developed in the studio.

Many artists of other periods have used their art to express the depth of their feelings about the people, places, and society familiar to them with vitality and integrity to create some glorious art. They really communicated and we can respond to their expressions in a very personal way. In the latter half of the 19th century, an inventive group of artists in Paris broke away from the earlier traditions and painted outdoors, *a la prima*, seeing ways to interpret the quality of sunlight through color, and express the mood and impact of the countryside and woodlands around Paris. They rarely returned to their studio to finish their paintings.

As a young man, Monet exhibited a simple, moody painting, almost a silhouette, done quite pointallistically, titled *Le Habre at Sunset, an Impression*. The name stuck and came to be associated with the entire movement; he and all his friends and fellow experimenters were known, not surprisingly, as impressionists. At the time it was not a compliment.

Rejected, even reviled at first as painters of rough sketches, they were eventually accepted and acclaimed. They have been enthusiastically emulated by large numbers of creative painters throughout Europe and America. Monet, Renoir, Cezanne, Pissarro, Degas, Van Gogh, Manet and many others are the masters we all admire for originating impressionistic landscape painting as we know it.

THE PHOTOGRAPHIC IMAGE

People have become so accustomed to seeing pictures as photographs that they have come to feel that paintings should look like photos; the closer they resemble a photo–the better they are. They believe if they aren't photographic, they aren't any good. I hope we can eventually educate the public to feel there is merit in different kinds of painting.

I see nothing wrong with recognizable subject matter, but I think it should also have the artist's special feeling and sensitivity to the subject and his response to it. There should be something left to the viewers' imaginations so they can enter into and respond to the artistic experience.

The artist's selective use of values, colors and strategic accents can delight and stimulate the viewer so a scene may appear to be truer to the spirit of the subject and seem to be more real than a purely photographic reproduction.

An impressionistic painting should be a creative, poetic expression of the artist's feelings about a subject. It wouldn't be just a literal, photographic reproduction of nature but an impressionistic interpretation of it. The beauty of this approach is that each artist sees things through his own eyes, tempered by his own experience and skill.

A strictly accurate, detailed copy of anything, whether it's nature, a photograph of nature, or especially another artist's interpretation of nature, says nothing about the painter, his relationship to his art or to his life and environment.

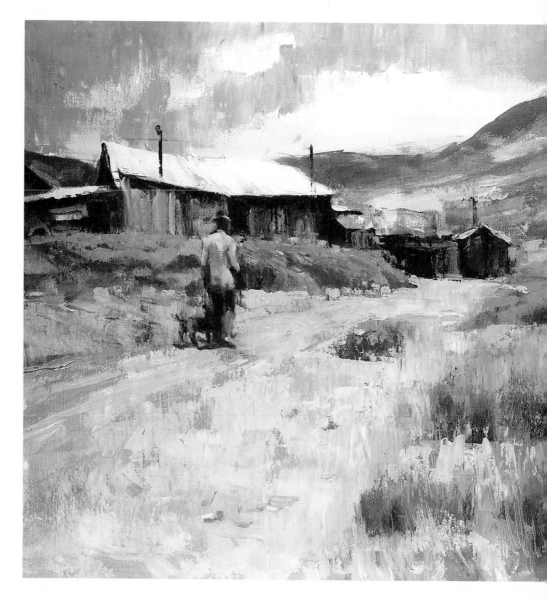

IMPRESSIONISM IN ALL MEDIUMS

Impressionism is usually thought to be related to oil painting. My purpose in this book is to help you see the essential qualities of your subject and give you a simple, workable procedure to express them in oils. You will find, however, that most of the great masters of impressionism worked with many different mediums.

Edgar Degas, of course, did a great many of his works in pastel, as did Mary Cassat, Pissaro, and others. All of them brilliantly sensitive and impressionistic.

John Singer Sargent's watercolors are thrilling expressions of mood and sunlight. His response to his subjects are as exciting as any of his oils. Winslow Homer worked in watercolor and line drawings, as well as oils, all very impressionistic.

Levitan, the Russian impressionist, did numerous pen or pencil preliminary sketches for many of his paintings. They had sensitivity, indications of mood, and a sense of mass, light and shadow, very simply expressed. These sketches guided him in the later development of his paintings.

Renoir's sanguin chalk drawings of children are just as impressionistic as his paintings, and equally exciting.

So, just keep in mind that it is what you look for and see in a subject, and interpret creatively with joy, excitement and understanding, that makes a painting impressionistic; not the physical aspects of the subject, or the medium used to interpret it. It's the spirit and feeling YOU put into it.

Feel free to express yourself in any way that pleases and excites you, and in which you feel comfortable. Occasionally shifting from one medium to another can be stimulating and provide new insights that will benefit all of your work.

Bodie — Ghost Town
This painting was done almost completely with a palette knife.

PEN
I like to use pen and ink to create tones.

CHARCOAL
This is charcoal on manila paper with white to complete the value range.

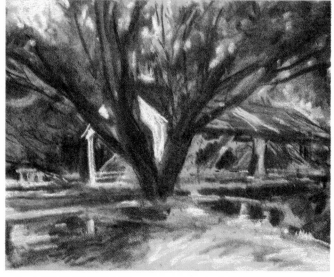

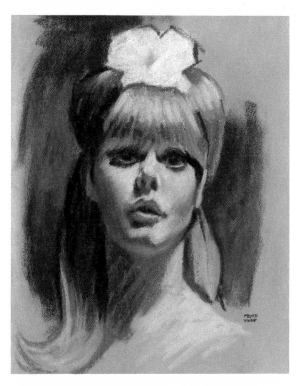

PASTEL
Pastel is a lovely medium and may be used impressionistically in much the same way as oils.

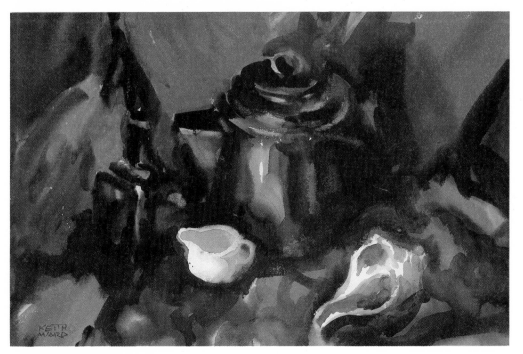

WATERCOLOR
Watercolor can be a direct, full-bodied, expressive medium. It doesn't have to be just a tentative sketch.

EQUIPMENT AND MATERIALS

The creative process feeds on itself. It requires continuity of effort. It is an accumulative process. What you have learned today is carried over and enhanced by new ideas and inspirations tomorrow. It is this continuing development that enriches each effort.

There is no standing still. If you break the continuity, an inertia sets in that is difficult to break. The longer the break in the work flow, the harder it is to start again and the longer it takes to regain the lost inspiration.

In order to maintain this continuity, it is necessary to have a place to work with your easel set up and your palette loaded, ready to go. Your brushes should be clean and close at hand, and you should have several stretched canvases in different sizes, as a choice of shapes and sizes might stimulate a special direction or choice of subject.

Hopefully, family members will be supportive and help with household tasks to allow you time to paint. Even a short amount of time on a regular basis is better than infrequent or irregular bursts of effort.

THE PAINTING PLACE

A place to paint is important. A spare bedroom is great or a corner of the kitchen, garage, or even the bathroom. If you have to take all your equipment out of a closet, set it up, and put it away each time you want to paint, chances are that it will seem to be too much trouble and the creative genius will be stifled before it has a chance to come to life.

PALETTE

You should have a good-sized palette. I use a plastic restaurant tray with a cover, 16" x 24". When not in use and covered, the paint will last quite well so you can feel justified in putting out a generous supply of each color. A small amount on the palette will only encourage you to use small brushes, too much thinner, and spread your paint too far. With the plentiful supply you can paint more freely with larger brushes. Use the paint mostly undiluted so you achieve a textural interest, impossible with thinned paint.

The large palette will give you plenty of room for mixing. I think paper palettes are a drag. They are usually too small, have a useless thumbhole, and have to be discarded too often to be useful.

At a builder's supply you can get bathroom tile board in small pieces or cut for you to about 16" x 24". Also, white lucite or plexiglass which usually comes in 24" x 48" sheets can be cut for you into three 16" x 24" pieces. Anyway, don't buy a palette at an art supply store that has a thumbhole. It wastes mixing space and you won't be holding it, you'll lay it on a table. The hole is the manufacturer's sop to tradition–to make it *look* like a palette.

Folding bus tray stands are useful and a better height than TV trays. These and the trays with covers can be purchased at hotel and restaurant supply stores.

Lay out any simple organization of your colors. A spectrum arrangement or warm to cool or dark to light, but do have a system. If you already have a system don't change it as old habits are hard to break and you might find yourself reaching for the wrong color. If you don't have a system, mine is as good as any. The main thing is to always replace fresh color into its allotted space to avoid confusion. You will quickly get into the habit of reaching instinctively to the right place for each color.

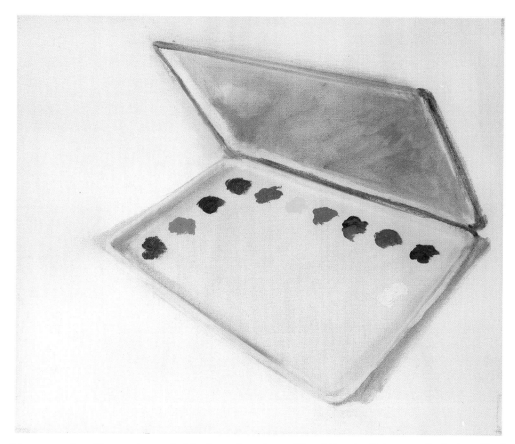

Your supply will remain workable for a few days. The Alizarin Crimson, Cadmium Red Light, Cadmium Yellows, and white are all very slow-drying. They will remain workable for a couple of weeks or longer if kept covered.

The rest of the colors will begin to skin-over in two or three days. For awhile the skin can be removed with a palette knife and the remainder be soft and workable, but when they start to get thick or sticky it is best to throw them out as they can never be broken-down to the proper consistency again and will only cause you trouble.

Sometimes a drop of *oil of cloves* on each dab of color will retard the drying and give you a little more time. Don't use too much—just a wee drop, or they may never dry.

The puddles of mixed paint in the mixing area on the palette will usually be coordinated to the color scheme of your painting and for a while, may be added to and used; but, if you retain them too long you will likely get too many different pigments mixed in and too much stirring together. You had better get rid of them before you start painting with "mud." Always put clean, clear mixes on your painting. Clean your mixing area when needed and start over.

After each painting session, scrape off all the mixed paint and clean your palette. You may think you can continue using it tomorrow but it will always dry and give you nothing but trouble. After a couple of days it will be almost impossible to get off. However, if you should forget to clean it, get distracted or called away, all is not lost. Take it outdoors and carefully spray the offending areas with oven cleaner, being careful not to breathe it or get it on the paint around the edges. Let it stand ten minutes or so then scrape it down (a 2½" paint scraper is good for this). If it is very hard it may take more than one treatment. You can then wash it down with thinner and it is as good as new.

PAINT

It is important to use as few colors as possible to produce the effects you want, so ideally you should be able to paint with the three primaries and white. This can be done by using Thalo Red, Thalo Blue, and Cadmium Yellow Pale (or Thalo), and white. This could be an exercise in learning the amazing range of colors and values possible with this ultimately simple palette.

From a practical standpoint; however, it is easier to supplement these with a few other colors: a warm and cool red, two blues, one yellow, a couple of greens and three earth colors. My palette consists of:

1. Alizarin Crimson		7.	Ultramarine Blue
2. Cadmium Red Light		8.	Burnt Sienna
3. Cadmium Yellow Pale		9.	Yellow Ochre
4. Permanent Green Light		10.	Raw Sienna
5. Thalo Green		11.	Titanium White
6. Cerulean Blue			

I find the limited palette quite satisfactory for all practical purposes. Sometimes I might use another color such as Cobalt Violet or Thalo Red for special pinks. Occasionally I might also use Cadmium Orange and Thalo Yellow-Green.

I have adopted the following arrangement of colors as the most practical for my work.

1	2	3	4	5	6	7
8						11
9						
10						

This is the arrangement I use but as I said before, don't necessarily change long-time existing arrangements as old habits are hard to break. Just be consistent and always use the same system.

Use the best grade of paint you can afford. Most of the well-known names are excellent. They each have slightly different painting characteristics. You will find the one that works best for you. Certain colors may vary from one brand to the next so choose the ones that you prefer.

BRUSHES

I use filbert brushes with rounded tips and a flat ferrule, shaped like the end of your finger. They are very responsive to your touch. The shape enables you to make almost any type and size of stroke with the same brush. For average size work, a #8 brush should be able to do it all: a broad covering stroke, a thin line, or both used with a twisting motion. With light pressure, any size stroke in-between, scumbling, and pointillistic applications are possible. For larger paintings you may need a bigger brush. For smaller details you will need smaller brushes.

You will find a #4, #6, #8, and a #10 will be all you need. However, you might enjoy some of the odd sizes such as a #5, #7, or #9. Use just a few at first and expand if you feel the need.

If you clean your brushes thoroughly with soap and water after each session they will stay like new for years. If you neglect them they will thicken at the ferrule and very soon become useless. Brushes are expensive so treat them lovingly. They are wonderful tools, largely handmade, so each one has a slightly different feel. Every once in a while you will find a real favorite that responds to your touch in just the right way. Unless you give it that loving care and daily cleaning it will quickly "go the way of all flesh."

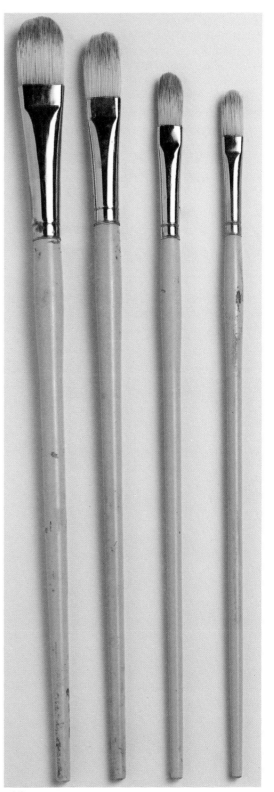

PALETTE KNIVES

Palette knives are used mostly for cleaning the palette, but you might want to apply paint with them for texture or other interesting effects possible with their use. Experiment and see what can be done with the different shapes and sizes.

My favorites are a couple of trowel-shaped knives, good for general-purpose cleaning and for applying paint to canvas. I think very small ones might be counterproductive in a bold, impressionistic approach.

PAINTING MEDIUM

A cat food size can is just right to hold your medium. You need something this large to dip your paper towel into.

A good workable medium can be made with a quart of high grade spar or marine varnish (not synthetic), a quart of linseed oil, and a gallon of paint thinner (all available at paint stores). Mix them thoroughly in a bucket and store in metal cans. Some plastic containers affect the chemical balance of this mixture and cause it to thicken and gel. This will make 12 pints of medium for less than $2.00 per pint. An equivalent mixture from an art supply store would cost $10.00 or more a pint. With materials getting so expensive, it seems a good idea to save wherever you can. I have been using this formula for years and have found nothing wrong with its use.

I rub this same mixture on paintings that have become dull and dry looking. It brings back the colors and a nice sheen without too much shine.

I trust some of these tips will prove useful to you.

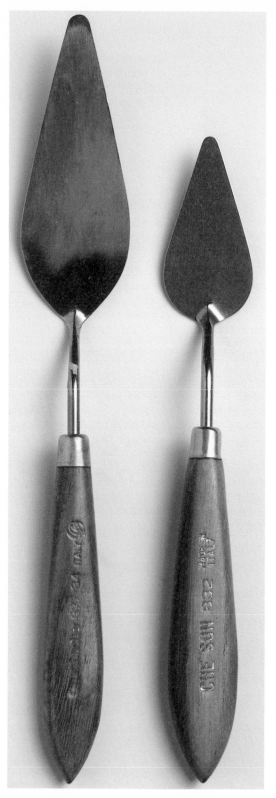

14

BRUSH WASHER

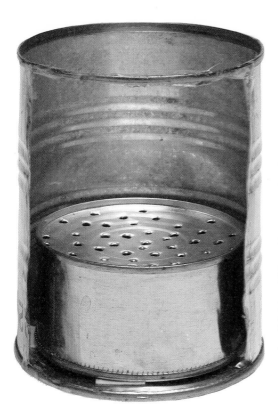

Your complete studio set-up should include a brush washer. This can be easily made from a coffee can and a tuna or cat food can. Perforate the bottom of the smaller can with an awl or nail, then place it upside down in the bottom of the coffee can. Fill the larger can ¾ full of paint thinner or mineral spirits. Between color changes, rub your brushes against the perforated insert and most of the paint will settle and keep you from washing your brushes in diluted paint.

For a while the solid paint will settle out from day to day and the thinner will stay quite clear. When it will no longer do this you can clean it out if you like, or discard the whole thing and start over.

Dry your brushes well after washing so you won't dilute your paint with thinner. Use rags, paper towels, torn-up sheets, or whatever you prefer.

CANVAS

Many people like working on a rigid surface such as primed masonite, wood or mounted canvas. All are good, but I really prefer the spring and feel of stretched canvas. A good grade of primed cotton canvas is excellent for most work. If you are a serious painter, I am sure you would enjoy the feel and quality of a good grade of landscape linen. It might be too expensive for student or practice work, but you might want to keep it in mind for later on.

If you are painting often, as I have recommended, you are going to accumulate a large number of paintings and storage can become a problem. A possible solution might be to temporarily tape your canvas to stretcher bars or masonite panels cut to stock sizes. They can be removed and taped to the wall to dry, then replaced by fresh canvas for another go at it. I was recently on a painting trip to Scotland and used this procedure with great success. The canvas was cut three inches larger than the stretched size so there was an inch and a half turnover on all edges. I then applied a minimum of staples with a staple gun set at a slight angle to the side. This left the staple with one side slightly protruding and made it easy to remove with a knife or screwdriver. The extra canvas then made it possible to restretch tautly with canvas pliers. Without the extra canvas over the edge it would have been difficult to pull it tight as there would be nothing to grip with the pliers. On the return flight the canvases took up a minimum amount of space in my luggage.

CHOOSING A SUBJECT

Most people have a hard time finding suitable subject matter to paint. This is a common dilemma. In years past, I remember driving maybe fifty or one hundred miles looking for the perfect, most picturesque spot, Of course, I usually ended up painting something familiar, close to home.

I think the first things to explore would be something commonplace such as an interior in your home with a figure; not done as a snapshot, but a meaningful relationship of figure to setting. Perhaps a natural still life like a table set for dinner or maybe already used, or a person reading the paper, or having breakfast in bed, an old coat hanging on the back of a chair, or kitchen things in a sunny window. The list goes on and on.

Your subject is relatively unimportant. It is *how* it is painted that makes it a painting. Great, magnificent scenes painted without sensitivity and imagination will not make a great painting. On the other hand, a very simple subject like a corner of a garden, a bowl of fruit or a bit of winding road, through the artist's interpretation and sense of excitement or poetry, can become very moving to the viewer and a true masterpiece.

Each time, try to extend yourself a bit beyond what you have done before. Each painting is a new problem. You mustn't settle on one method or technique and feel you have a formula that will work for everything. You will have to invent new techniques and ways to express each new challenge.

The types of scenes on posters, postcards and calendars do not always make the best paintings. Choose your subjects not for their picturesque qualities, but for their patterns and interesting shapes and qualities of mood. Anything that excites your interest.

Ideally, work on location for landscapes, from live set-ups with real flowers and fruit for still life, and from live models for portraits or figure paintings. You will get a really personal response to the subject that is very hard to achieve from a photo.

Of course, these real subjects may not always be available so make use of your camera and take lots of pictures. Look for interesting patterns and shapes. Search for the same sort of compositions that you would be painting directly. You can build up a great collection of paintable subjects.

When using photographic material, don't try to reproduce the photo, but use it creatively, trying to remember and recapture the mood and quality that appealed to you at the time. If there is time and opportunity, try to supplement your photos by making small "thumbnail" sketches (about 4" x 6"). Make them small so there will be no attempt to include details, just the large shapes and masses to remind you of the mood and relationships that attracted you. The photo will supply all the details and a lot more than you should use.

As time goes on and you become more sure of yourself and are learning to see pictorially, you will see picture possibilities everywhere. You will retain more and more information in your memory that you can use to help you recapture the qualities you want in your painting. You will paint more and more from memory.

If you are excited by pictorial possibilities in published photos in magazines or other sources rather than your own, be very careful of how you make use of them. Make definite changes in the composition by deletions or additions of elements, modifying relationships, mood, color scheme, and time of day — make it your own free interpretation of a similar situation. Don't make a copy of someone else's composition. Not only is it wrong to copy someones creation and call it your own, but some of these things are protected by copyright.

Thumbnail Sketches

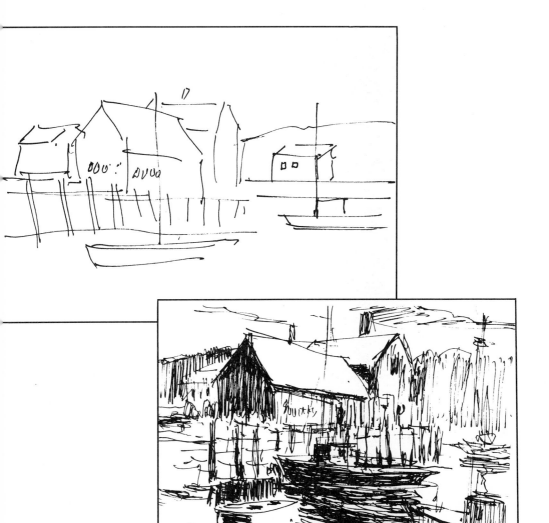

A sketch like the one at the top tells nothing but the fact of the number of houses and does little to remind you of the characteristics you would want to portray in a painting.

The sketch at the bottom; however, with tones suggesting the patterns of shadows and a more thoughtful indication of the mood may remind you of your impressions at the time and be a real help in making a painting. It could also be a valid work of art on its own.

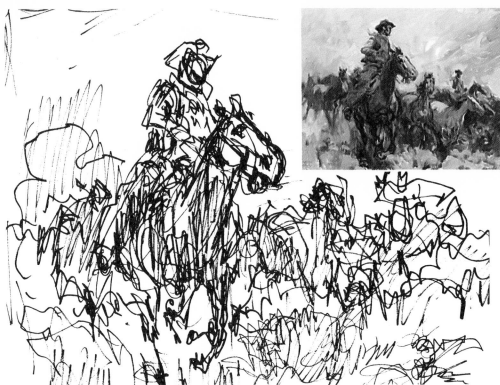

This is a simple sketch done with a fine-point, felt tip pen for action and mood. It is one of a series of experiments done for this subject in the studio. The finished painting is shown at the top.

Below is a brush and ink drawing with watercolor added, done on location. This was done quickly to get a good, strong tonal sketch with color.

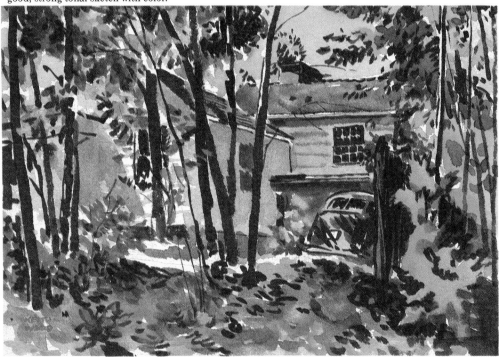

PRELIMINARY SKETCHES

Sketching in the field is an exciting and valuable exercise. The sketches are likely to be accurate expressions of your responses because they are done spontaneously and rapidly with full realization of the total quality of the subject. They are used for reminders of relationships and moods rather than just a catalogue of the objects in the picture.

Many years ago, when I was doing illustrations, clients (especially in advertising) usually wanted to see very comprehensive sketches before approving the project. They wanted to see exactly what their ad was going to look like in the magazine – even the typesetting. When it came to making the finished painting for reproduction, I found I had done all my creative work on the sketch and all I could do was copy it exactly. It usually lost its spirit and freshness and wasn't as good as the original sketch. I was eventually able to do my "prelims" as quick sketches in a different medium (such as pencil or pastel), so I could do my creative development on the final painting (usually watercolor) and have much better results.

I recommend that you try this procedure and do your preliminary sketches in one of these mediums, then do the finished painting in oils. Do not forget that direct painting in the fields is desirable and stimulating and is an end in itself. Many of your sketches might be your complete expression of the subject and end up framed and shown, or at least developed further.

Here are a half dozen preliminary sketches, several of which have been developed into paintings, each one in a different medium; all involve easily portable materials. You can take materials like these with you almost any place you go.

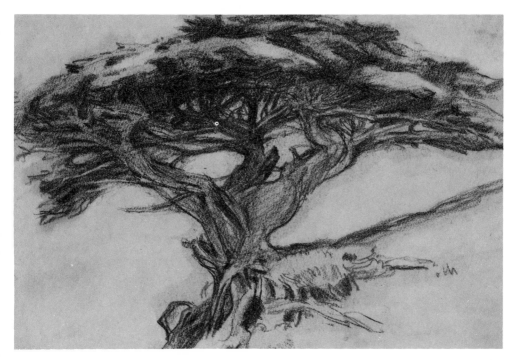

This sketch of a tree was done with a charcoal pencil which is a good basic way to make contrasty studies in the field. All you need is a charcoal pencil and a knife to sharpen it, or some conte crayons and a small sketch pad. Be sure to work for tone and values. This sketch was made on a very productive sketching trip with an artist friend in 1929!

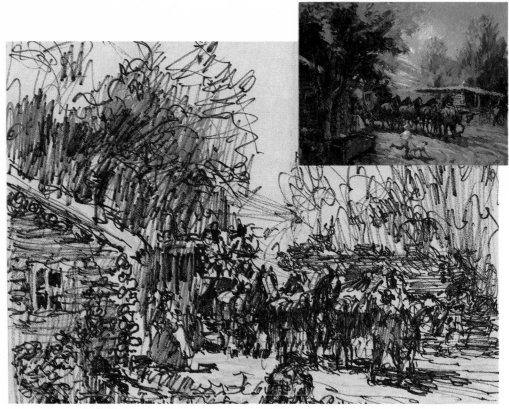

This sketch of a stagecoach stop is the culmination of a number of compositions done in the studio. (The actual sketch is almost four times the size of this reproduction.) The sketch was done by scribbling tonal shapes and general movement with a felt tip pen; color was added with markers. The 30" x 40" painting was done directly from it, also, of course, using my imagination.

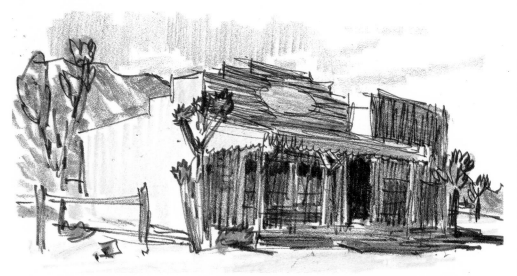

This sketch was done with colored pencils at Pioneertown, originally a western movie set near Yucca Valley, California; now a ghost town. This is a great way to get a good color study, and you can easily carry a box of colored pencils and a sketchbook in your pocket wherever you go.

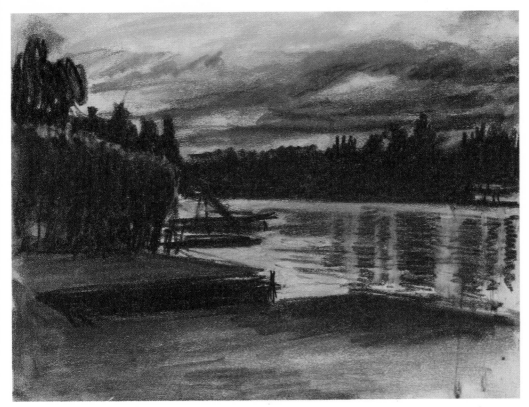

I did this sketch about forty years ago at Lake Oswego, Oregon, where I had a studio at the time. I was intrigued by the late sunset condition, but had to work very quickly as it was dusk and the light was going fast. I used hard pastels called "nupastel," small square sticks that are very easy to handle. I had an elaborate set of a hundred or more colors, but they are also available in smaller assortments that can be easily carried with a sketch pad in your coat pocket. A spray can of fixative is a good idea so you won't smudge your work on the way home.

One word of caution about painting on location. With the world as it is today, I suggest that you not go out in the field alone. Take one or more artist friends with you, both for companionship and security.

One of my students in Las Vegas used to paint alone in the desert. She was a wonderful, hearty woman, born and raised in Helena, Montana; afraid of nothing. However, she would tie the leash of her huge black cat, Blackjack, to the leg of her stool; he looked like a black panther. (I once painted his portrait; he had one white whisker.) She also placed a "45" revolver on a stool beside her; she was capable of using it if need be. She was never bothered.

Few of us are up to these tactics, so just be careful.

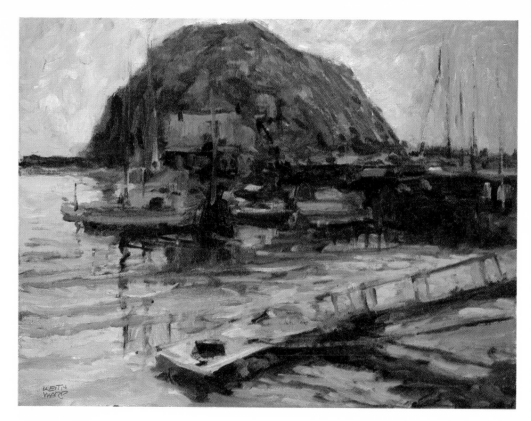

Morro Bay

COLOR USED IMPRESSIONISTICALLY

The relationships of colors offer the greatest possibilities for creativity in painting. The interaction between warm and cool colors activates an area and creates the illusion of local color in light. Paint is used as a creative medium rather than a coloring medium. This interaction happens when you place strokes and spots of color mix next to each other on the canvas rather than thoroughly mixing and matching on the palette.

We are creating illusions of reality, so we are not too concerned with the local colors of objects, only the way these objects appear under certain light conditions and other influences.

Complementary colors placed next to each other will appear to vibrate or shimmer along their adjoining edges. This phenomenon creates an active and lively relationship in a painting. This applies to large, simple compositional shapes as well as an intermingling of small brush strokes of complements to create texture and an active surface.

In the practical application, it isn't always necessary to achieve exact complementary relationships in order to create color activity. Interesting juxtaposition of relatively warm and cooler colors will create the illusion of light and atmosphere. For instance, a pinkish-lavender with a bluish-lavender, or perhaps an orange against a yellow-green, in the right context, might create an interesting relationship.

This detail shows how the intermingling of warm and cool colors creates a sense of light atmosphere in the sky.

This detail of the water area illustrates the complementary interaction of the orange sky reflection on the waves and the blue of the shadow side.

These effects are apt to be more effective if the combinations are within a close value range. The sun shining on a lawn will give the illusion of green grass. Actually, it is made up of many variations and values of green. If you were to pick some of the grass and bring it to your palette, mix and match the color exactly, then paint it on your canvas, it wouldn't create the illusion of a sunny lawn at all. You would have taken it from its environment and condition; these things are the elements you should be painting. The green in the sunlight would be light and warm, with more yellow. On the other hand, the grass in the shadows would be darker, more subdued, cooler with more blue. Neither of these is the actual color of the grass, but in their context they create the illusion of a sunny lawn.

While painting you will be squinting at the subject and constantly comparing the relationships of the colors on the canvas. You might feel, for instance, that a certain green is too raw, and appears to need some orange or even red, perhaps from a late afternoon sun. You wouldn't necessarily mix a new color and paint out the original green, but you could take some of the modifying color and mingle it on the canvas by scumbling, dry brushing, flecking or spotting; to modify without destroying the integrity of either one. You get a shimmer and vitality impossible to achieve by just applying the mixed color, though you might combine both procedures.

This color activity is caused by the fact that warm colors advance and cool colors recede. Sometimes a little Light Cerulean Blue introduced into the distant area might help set it back; while a bit of red splashed into the foreground would bring it forward.

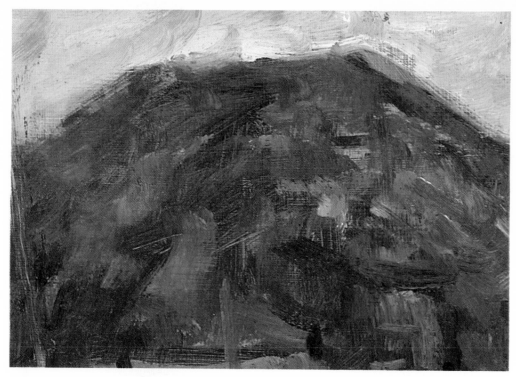

This detail of the shadow side of the rock (from the painting on page 22) shows how a variety of relatively clean, dark colors combine to create a vibrant neutral tone.

Cool colors give a sensation of quiet, serenity and calm, while warm colors are exciting and stimulating. A painting of predominately cool, darker colors suggests dusk or overcast skies, very moody, dim light; evening, fog, or misty rain. The close values also contribute to the mood.

Sunlight calls for strong contrasts: bright sunlit areas and dark, cool shadows. Bright reds and yellows are lively and exciting. They come forward in a painting. Cool blues, lavenders, and greens recede. Bright yellow-greens fall into the warm category, as do red-violets and pinks.

Dark, somber, cool colors, contrasted with the excitement of strong darks, create the sensation of storm and menace. High key, predominately warm colors are sunny and happy. Light, high key cools will contribute a feeling of clean, fresh, early morning.

The four seasons are also associated with color. Light, airy skies, pale yellow-greens in the trees and grass, pinks and whites of blossoms, and lighter, clean, cooler colors for shadows indicate spring. In summer greens get darker and cooler, trees are more solid, shadows are dark and strongly contrasting to the light and brightness of sunlit areas. All colors are generally stronger and more intense. Autumn brings dramatic yellows and reds. In the beginning they are mixed with greens, then finally give way to winter with fallen leaves on the ground. Bare branches on the trees stand out against paler and grayer skies. Winter becomes somber and grayer with cooler colors and closer values. The sun on the snow becomes brilliant in contrast, but not necessarily all blue and white. The color schemes relate to the quality of the light, possibly quite warm: pink, orange, or lavender. If you are impressed by the glare and whiteness of the snow, paint it that way, even to playing down or eliminating some of the shadows.

UNDERPAINTING

Often the blank white canvas can be an intimidating stumbling block when starting a painting. For this reason I like to put a tone on the canvas to break the impasse.

Pour a puddle of medium on your palette. Then dip your paper towel into the medium and then into Raw Sienna, making a rich wash which you apply to the canvas in broad sweeping strokes (like washing a window). Next, dip the same swab into Cerulean Blue (again making a fairly rich mix), and with the same vigor, apply it into areas left open during the application of the Raw Sienna, using the same bold, non-directional approach as before. (Other colors can be used if they seem to be more compatible with your subject.)

This leaves the canvas covered with an interesting combination of warm and cool colors which serves several important functions. First, it eliminates the blank white surface and provides a light middle tone underpainting on which both light and dark shapes will appear in a truer valued relationship to each other. It also provides a moist surface on which your subsequent brush applications will move around freely. You will be painting wet-into-wet.

Then, if done freely and vigorously, it will provide a much more stimulating beginning than a smooth ground, as if something were already happening, and it gets your creative juices flowing. Therefore, be sure not to work the colors together or smooth them out too much.

Your underpainting can be warmer or cooler by letting one color dominate over the other. In a seascape, the blue could dominate, while a fall scene might have more Raw Sienna. In any case, the toned ground will unify and hold the painting together as it progresses.

USE OF THE PAPER TOWEL

Some twenty-odd years ago I was on location in the desert doing a large painting. The entire foreground was in the shade and I became frustrated by the rapidly-moving shadows on the canyon wall and just couldn't cover the canvas fast enough, even with a #12 brush. So, I grabbed a wad of paper towel and making a wash of my shadow value and color, immediately covered the large shadow area. This gave me a good base to quickly put in some details of rocks and sagebrush. The whole effect was accomplished in minutes.

This worked so well and was such a breakthrough that I have used the procedure to begin every painting I have done since, no matter what the subject; landscapes, seascapes, still life, and even portraits.

Some of my students have found the paper towel to be such a useful tool that they use it to the ultimate degree and complete their painting with it, right down to the final detail. Used in this way it is a most useful and rapid way to complete a sketch on location.

In one of my recent classes, a young student completed a 3' x 5' painting this way in a single class session and never used a brush. He entered it in a local show and won the first place ribbon in its category and an award for best of show.

Even minimal use of the paper towel quickly produces a simple understanding of what the painting is going to be, with pattern, tone, color, and mood.

Undoubtedly there are many other ways to do the underpainting, the pattern and other beginning stages of a painting than to use a paper towel. Perhaps a rag, a sponge, or even a large brush could be used. However, I have found through many years of trial that a high-quality paper towel works best.

Find a paper towel that is strong and absorbent. It should hold just enough diluted paint without running or dripping. It should not flake off if you have a good quantity of paint and don't bear down too hard on the canvas.

Fold a single towel across in both directions. Then bring the corners in to make a handle, using the center as a round swab to cover the large areas. Later, to accomplish lines or edges, it can be pinched-in to do trunks of trees or masts on boats.

It would defeat the purpose if you were to put your finger in the middle and use it like a piece of charcoal to make lines. The whole idea, of course, is to enable and encourage you to see the large shapes and masses at this stage and avoid details.

NO DRAWING ON THE CANVAS

Most people go through life without really seeing what they are looking at, and have preconceived ideas of the way things are. This makes it very important to first learn to really see things in their true relationships and conditions in order to draw them; to achieve the skill to put down with the hand what the eye has observed.

When making observations from nature or from photos of nature, all parts of the scene are realized as shapes, not as shapes surrounded by lines. Strictly speaking, there are no lines in nature, only edges of one tone against another. Trees are seen as silhouettes against the sky, as are mountains and canyons. Houses and buildings are also shapes against their backgrounds, whatever they might be.

Twigs and small branches of bare trees are lineal, but even these can be thought of as being contained within the boundaries of the tree and create a lighter tone against the sky.

I believe it might be difficult to achieve an interpretive approach to painting by starting with a careful and complete line drawing on the canvas. The better and more precise the drawing, the harder it would be to avoid painting carefully between the lines with a small brush; thus ending up with a colored *drawing* instead of a painting.

You need freedom from these restraints in order to keep observing the big shapes and relationships, and interpreting them with large brushes and a free-flowing, vigorous, creative application of the paint; making the painting a meaningful, unified interpretation of the subject.

Just because I suggest starting a painting with patterns and shapes instead of careful drawing, doesn't mean I don't want you to draw. You are drawing all the time you are painting and making observations or considering what you are going to do.

It would be a very useful thing for you to draw as often and as much as possible, a little every day if you can. Draw not to learn to copy, but to understand the meaning of the forms and their underlying relationships. Draw people as well as inanimate objects and do it with as much appreciation of the qualities and depth within the forms as you can. Draw in the same terms you would be considering if you were painting.

There is no end to the things to be learned and understood, and learning is one of the main joys of life. You acquire an understanding of values and form and discover a means to express them as simply as possible. A turn of a line can enclose a mass and suggest its value and characteristics. Sometimes the absence of a line or the diffusion of an edge can be more expressive of the quality of the mass than exact definition would be.

The more you know about any subject the better you can paint it. Knowledge and skill in drawing will become a tool that you will use in your painting without conscious thought or effort. So practice as much as you can.

Make small "idea sketches" of your subject, analyzing the different possibilities. Then do drawings and studies of various detail, figures, perspectives, et cetera. When you start on your painting use those sketches and the knowledge you have gained by doing them as guides, and then do your creative work directly on the canvas with paint.

The use of the drawing on canvas tends to make everything hard-edged. Lost edges, thoughtfully conceived and artfully placed, can help make the elements relate to each other, become a part of, and merge with the background and help direct attention to the center of interest.

It is possible to make a painting with very few hard edges, even architectural subjects, and have great mood and unity.

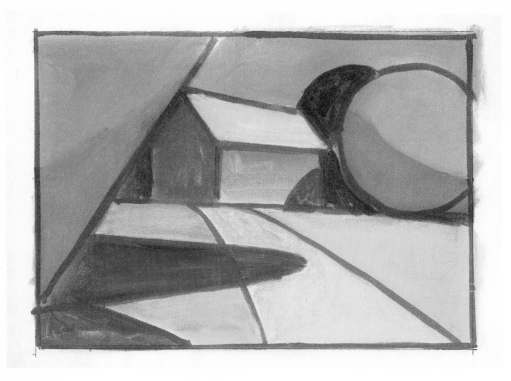

THINK SHAPES

Shapes, as we observe them, are not necessarily the shape of the objects themselves, although they might be. They may instead be the shapes of shadows, color, or tone. They may be abstract or geometric, and may very well override the boundaries of objects and things.

All shapes in a picture, including the negative shapes of the sky or background, are equally important to the pattern. Negative shapes of sky, for instance, will define and confirm the shapes of trees or the perspective of a roofline. Many triangular shapes will be involved with the perspective of roads, fences, or parts of a mosaic.

These are what you will be looking for no matter what the subject, or whether it's from nature on location, or from a photo in your studio.

In portraiture, the subject can also be broken-down into geometric or non-objective shapes. These shapes are in both the large compositional considerations as well as in the small shapes of shadows and lights.

In still life the same thing holds true. A large, simple compositional shape surrounds all the elements. It is then broken and divided into shapes of shadows, lights and colors.

RELATIONSHIPS

Everything is relative. Shapes are large or small, long or short, wide or narrow, depending on their relationship with their neighboring shapes. A tone is light or dark depending on the value of the surrounding tones. A middle tone shape next to a dark shape will appear to be light, while the same tone against a very light area will seem to be dark.

When painting, you cannot isolate your thinking. When working in one area, be aware of all the other areas of the painting. Constantly check the shapes, sizes, and colors of the area you are painting against the other areas of the picture to make sure they relate properly. No one part should stand alone.

Branches against the sky do not have to be painted the same dark color as the tree trunk. Perhaps, if they were painted a lighter color, they would still be silhouetted against the sky, but not visually separated from the total mass of the tree.

"Sky holes" in trees, if painted the same color and value as the sky area, will most likely stand out from the tree mass like spotlights, or just spots of paint. On the other hand, if they are painted a slightly deeper tone of the sky color, they won't break up the unity of the tree mass and they will still look like openings to the sky.

Mountains and clouds are always varied in size and shape. Novices often paint preconceived ideas of things instead of making accurate observations. I've seen a painting of a range of volcanic cones, evenly spaced with perfectly round clouds hovering over the valleys like eggs in a carton. As symbols they were okay, but as representations of nature they needed the interest of variety. A row of trees, even if planted, will grow in varied shapes, not like the first example, but more like the second.

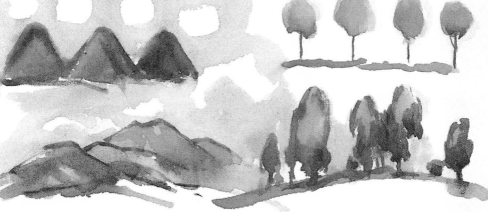

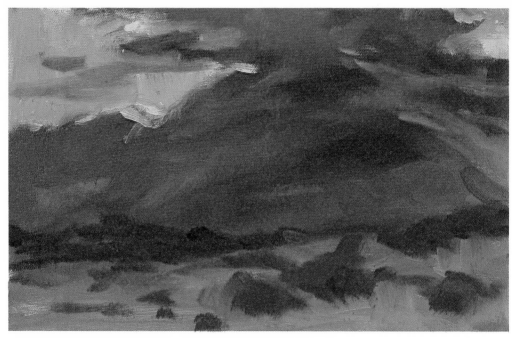

CREATIVE THINKING

These four sketches were done as a demonstration to help encourage students to break away from complete dependence on photographic copy. They were done from memory of Mt. San Jacinto which I have observed in many moods.

In learning to see pictorially, you will be constantly aware of natural phenomena, such as light conditions, colors and shapes of hills and trees, perspective, et cetera. You will very soon acquire a valuable fund of information in your memory that you can draw from while

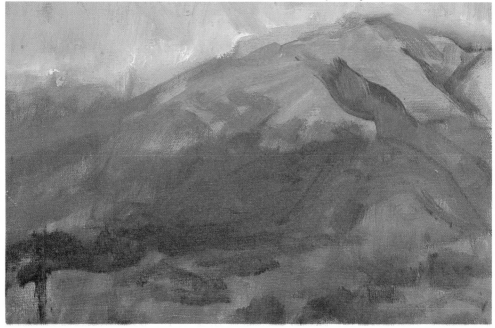

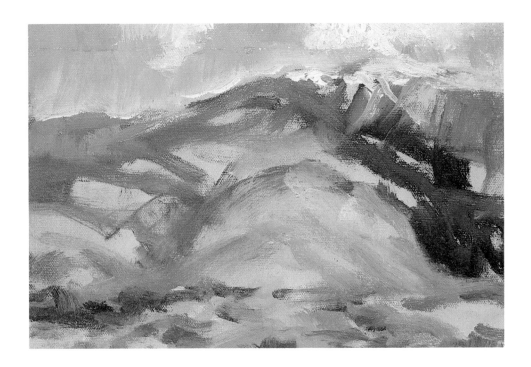

you are painting, and you will always be adding to it.

For an exercise in creative thinking, try taking a favorite subject and imagine how it would look under different light conditions, time of day, or various seasons; then paint a number of these different versions. Copy this exercise, if you like, to get you started. If you persist, you will be amazed at the ideas you will be able to conjure up from your subconscious memory.

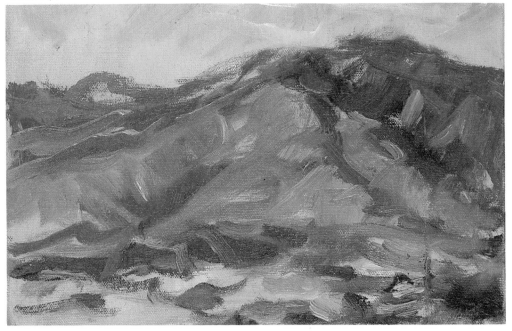

COMPOSITION

Composition should be a natural and comfortable distribution of the elements in a picture with logical relationships created by rhythmic patterns and movements. All the elements should be included from the beginning and should not be added as afterthoughts. For instance, figures in a landscape would be included in the original plan and their activity related to the mood of the subject and vital to the expression of it.

Elements of a still life should be arranged to create a movement and balance and have a meaningful relationship to each other. Hopefully, after the painting is developed, it should not be necessary to add objects to try to complete the balance and movement.

In a natural scene, it might be necessary to make strategic adjustments in the size or location of some of the elements, or even leave them out to benefit the arrangement. These adjustments are best made in the early organizational stages of the painting.

It is the visual aspects of a subject that create the shapes and patterns, and each shape, including the negative shapes, is equally important. You wouldn't paint the sky all the way across the canvas and then apply trees and other objects on top of it. That would put the emphasis on the things instead of their relationships. You see the trees, and the sky is seen around and through them. Only paint the areas of sky that are visible to you. The total visual impact of the entire subject should be realized on the canvas all at once, not piecemeal, in order to maintain the relationships and the unity of the organization.

Painting is a completely personal expression. It is a communication of the artist's insight into the mood and quality of a subject and his reaction to it. The artist hopes to project these qualities to the viewer to share his pleasure and excitement.

It seems to me that rigid rules such as "you must always do this" or "you must never do that" are inhibiting to free expression and counterproductive. There are some guidelines that are often useful but even these can be successfully ignored if it serves the purpose of your composition to do so. Look for new ways to express an idea. Let each painting be an adventure, exploring and expanding your own potential.

Perfectly equal divisions of areas will usually be less interesting and exciting than varied sizes and shapes. Repetition of spaces and shapes hardly ever appears in nature. There is interesting variety in the sizes and distribution of rocks, trees, clouds, and the tops of mountains, et cetera. Observing and recognizing these differences is an important part of creating a meaningful impression of nature. Learning to see is an all important part of composing a painting. Follow your instincts and make your paintings as varied and interesting as you can.

Horizontals and verticals are lines of serenity and quiet. Diagonals, zigzags, and curving lines are lines of action and suggest something exciting is going on.

There are many ways to direct attention to centers of interest. Converging lines point the way. The most exciting contrasts of dark and light, the brightest colors and lively shapes and edges all help.

Conversely, close values, subdued colors and soft edges cause these areas to recede and stay in the background or guide the eye toward the more exciting areas of greater interest, not necessarily at the center of the canvas.

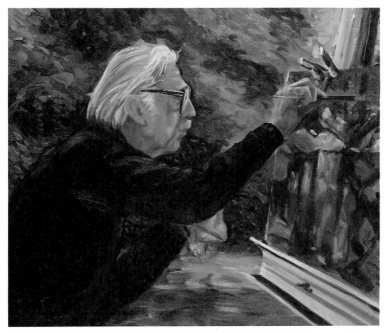

This is a portrait of me, "Painting With Vigor," done by one of my students, Walter Pfyl.

PAINT WITH VIGOR

Hopefully, we will all continue to be students for the rest of our lives. We can always be open to new ideas, learn to see with fresh viewpoints, find new ways to make color and tone work for us, and keep experimenting and looking for fresh approaches. Not newness for its own sake, but because there is always a simpler, more expressive way to combine colors and relationships to get at the true beauty and meaning of our subjects.

Many students approach a canvas timidly, with fear, trembling, terrified of making a mistake. This is the greatest mistake of all. Actually, it is almost impossible to make an irretrievable mistake in oil painting. You can always scrape off and paint over or make changes. Anyway, there is no absolutely right or wrong way of doing it.

Never let fear keep you from making the most of your opportunity to make a creative statement. Be adventurous, leap in and let vital things happen. If you are going to make a "mistake," make it because you jumped in and did something positive. Don't let the painting fall by the wayside for lack of having made a positive statement.

I don't think that speed in painting is important for its own sake, but it does seem that rapid observation of a subject does have the merit of seeing it all at once in its unity and essential mood and relationships. The rapid application of the paint has vital and stimulating qualities that are apt to be lost in over-painting or in a deliberate and analytical approach. Be outrageous, be bold, but don't be fearful.

Painting is a communication of the artist's special understanding of the depth, beauty and importance of a subject. It enriches and enhances the lives of the viewers in sharing the artistic experience as well as the artist in producing it.

So, don't just paint pretty pictures–photographic copies of things, but paint the illusion, the poetry, and the spirit of nature, Paint with vigor. There is genius in everyone. You have it in you to paint masterpieces.

RHYTHMIC PATTERNS

The pattern in a picture is the structural foundation which ties all the elements together in a unified organization. It is usually created by the shadows and other dark shapes moving from one to another, forming a sense of movement through the areas of the picture. This movement with accents of dark and light (enhanced by color) becomes the picture.

Sometimes the pattern will be a converging system of lineal movements related to the perspective of streets, roads, forest streams, or a row of trees. It might be made up of shadows combining with dark masses of foliage. Usually the patterns will override the boundaries of physical objects. The subject becomes secondary in importance and usually evolves during the continuing development of the pattern.

A useful exercise to help you get used to the idea of looking for patterns in your subject (rather than objects and things) is to collect a dozen or so old photos or clippings of different subjects, and on a pad of paper, try to analyze the pattern of the darks and roughly put it down. Squint to eliminate some of the details and minor variations of tone. This is also a great help in making observations from nature.

PAINTING PROCEDURES

Using the paper towel swab, make a new mixture on your palette of Burnt Sienna and Ultramarine Blue diluted with medium to make a rich wash of a dark middle tone. This is a good general, all-purpose mixture for most darks, varied toward warmer or cooler as desired.

Study your subject. When you decide what your simplest patterns and movements are and how they relate to the space, put them down directly, boldly, and roughly. Don't attempt to draw anything at this time. Don't analyze any edges to make them look like something.

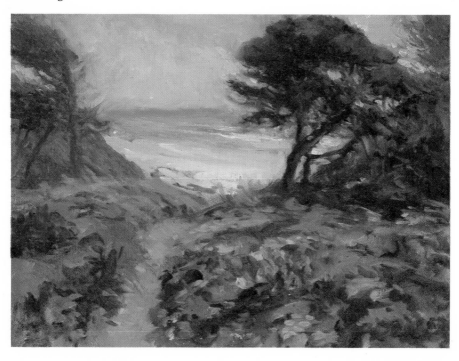

The second consideration in the development of the underpainting is to locate strategic dark accents, mostly within the rhythmic pattern area. These accents are a part of and a further development of the pattern itself.

Everything that is put down during any stage is to be thoughtfully considered so that each step will lead logically to the next. It should contribute to the development of the painting without having to backtrack and make serious adjustments or alterations to the values. Make it a continual refinement, development, and enhancement of the entire painting.

The accents are produced by taking the same paper towel and dipping into the Burnt Sienna and Ultramarine Blue to make a very dark color. I use this combination to create most of my darks, up to and including black, with warmer and cooler variations.

Take this rich, dark, almost undiluted paint on the paper towel and add the shapes of the darkest spots or areas. The consistency of the paint for accenting will be the same as you would use with a brush, but the use of the paper towel will keep you from considering small details at this stage. Squint your eyes and see only the largest, simplest shapes. The sense of action may exist naturally in the subject or may be established by your own creativity.

Now, still using the paper towel, start painting in the simplest shapes of local colors: green in the light areas of the grass and trees, color of the sky, and perhaps sky reflections in the water, red on barns, et cetera. Smear the colors on quickly without concern for precise drawing or edges. Smearing it on will spread it thinly, and make a receptive surface for future brush work.

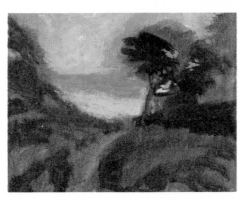

Having established most of your middle tones and darks, it is a good idea to establish the lightest areas in your picture. It might be a warm white on a house, or clouds, or breaking waves, yellow fields of grain, or fall trees. These lights will complete your value range so that everything will relate properly. The color of these lights is not that important yet, as long as they are warm or cool according to your observations. They can still be applied as straight pigment with the paper towel.

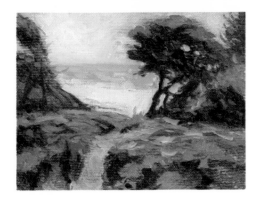

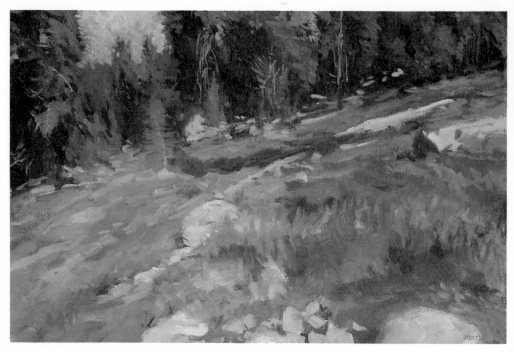

Hillside Clearing

SHAPES--
Radiating Lines

In this subject I was impressed by the strong, dome-like mass of the cleared hillside, created by the curved, radiating lines of the logs and rocks on the slope. The dark forest was blocked in as a perfectly flat, strong, dark shape. The sky was used as a negative shape to create the texture of the branches of the sequoias in reverse.

Details and textures of the trees and branches, as well as the undergrowth, logs and rocks, were added later.

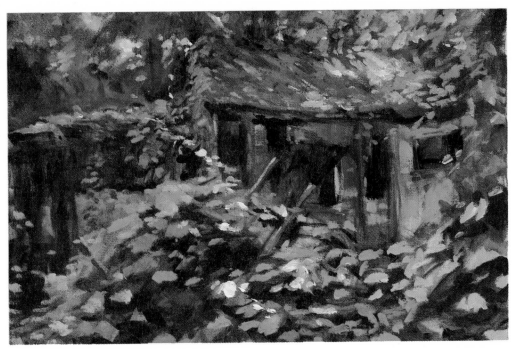

Montanez Adobe

I was fascinated by this old house completely overgrown by a jungle of eucalyptus, palms, ivy, and wild grape. It had been added on and reroofed with every conceivable kind of material many times over the years. There was barely room in the tiny clearing in the overgrowth to set up my easel.

The canvas was toned with a wash of Raw Sienna and Cerulean Blue. Then the first thing that struck me was the shape of the shaded side of the house, and the undulating forms of the grape vines. So, I used this shape as a foundation for the composition, with a middle-dark wash of Ultramarine Blue and Burnt Sienna.

I then added the tone of the leafy background above the roof and the shadow pattern of the grape leaves and dark accents of the windows and doors. No house was drawn as such; only the shapes and areas of tone. Color was applied for warm lights, cool shadows and textural interest in all the areas.

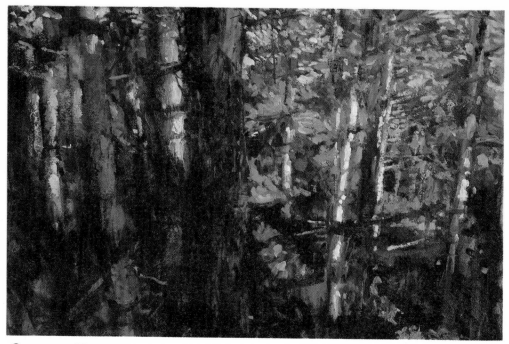

Oregon Forest

SHAPES

By squinting you can ignore the complicated pattern of the trees and see that the design of this picture breaks down to three triangular shapes: (1) the shadowed hillside on the left, (2) the smaller shadow in the lower right, (3) the remaining sunlit area in the center. The dark shapes were put on the toned canvas with a wash of Burnt Sienna and Ultramarine Blue, applied with a paper towel. The light triangle was applied in the same way with yellow as an underpainting to enhance the feeling of sunlight.

The lines of the tree trunks were then added, slightly converging to convey the idea of perspective, that you are looking downhill.

The finishing process consists of the secondary pattern of shadows and foliage through the trees, and the introduction of color into all areas. The feeling that this is just part of a large forest is conveyed by the implication that you are standing in the middle of it and it goes on and on, endlessly, in all directions.

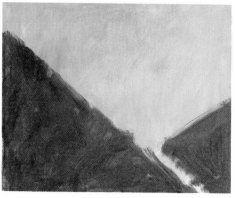

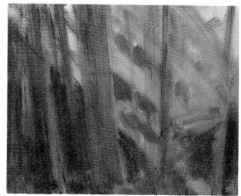

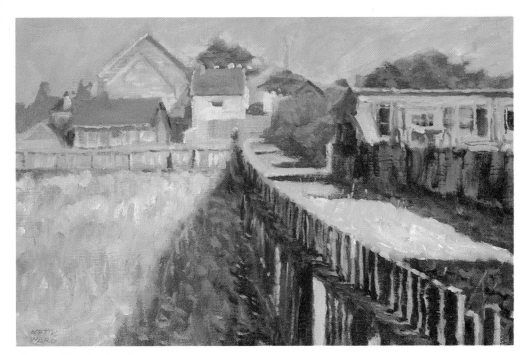

Mendocino Fence

RADIATING LINES

In scenes that have a one point perspective, find the point where the lines converge and draw the horizon line through it. Then make a series of lines (like spokes on a wheel) radiating from the vanishing point.

On this structure of radiating lines, block in the pattern of mostly triangular shapes. As usual, do the dark shapes first. The rectangular shapes of the houses follow the horizon, while the peaked roof lines and the tree shapes are based on the radiating lines.

The feeling of sunlight is accomplished through the interplay of colors, mostly warm in the lights and cool in the shadows. Notice the variations of color in the sky, grass, and shadows that create color vibrations and texture.

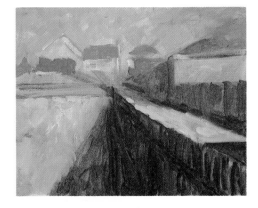

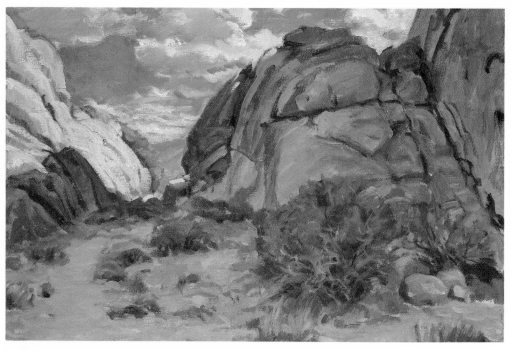

Joshua Tree

CONTINUITY OF LINES

This picture is one of a series painted some twenty years ago on location at the Joshua Tree monument. This is a spectacular place on the edge of the Mojave Desert, full of strange, eroded rock formations, reminiscent of ruined Egyptian temples.

Painting on location is always challenging, as you can get a truer feeling of the spirit of a subject than you can from a photograph.

The lines of this composition, to all intents and purposes, extend from corner to corner, intersecting at the center. However, the shapes of the main masses of lights and darks create an unequal balance that overrides the apparent equal division of the spaces, and gives the composition its rhythm, movement and variety.

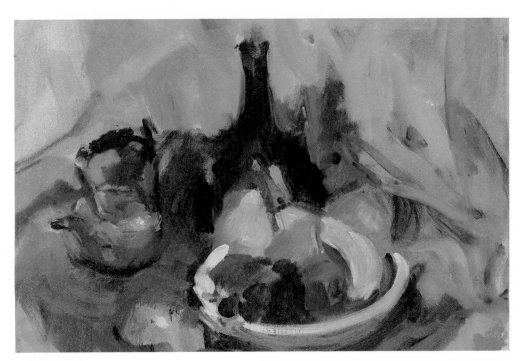

*Still Life
Bottle and Fruit*

SHAPES

In most still life paintings I find it useful to organize the elements of the subject on the canvas by putting down a simple structure of enclosing lines which create a compositional shape. This not only includes all the parts, but establishes their location on the canvas and the shapes of the negative spaces around them.

In this painting, a curved line separates the background from the foreground. Superimposed on this is the shape created by the lines that surround all the elements. This makes it easy to locate the pattern of the darks and then the shapes of the color area.

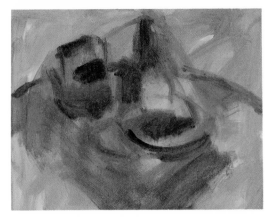

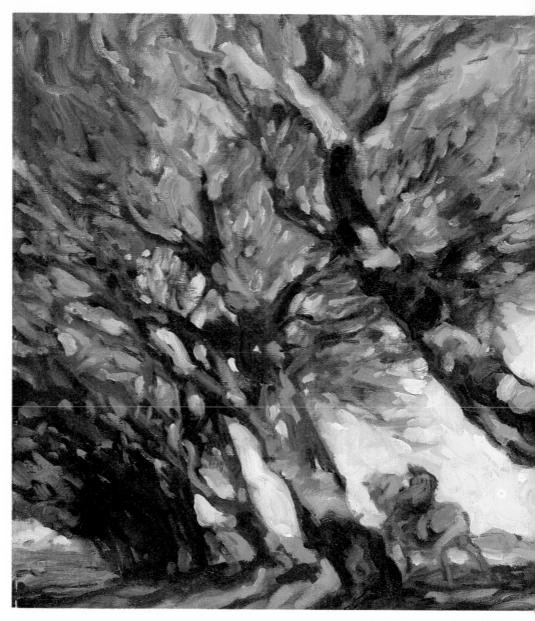

Trees In The Wind

This was painted from a row of windblown trees observed on Maui. Complete freedom
was taken with color. Strong reds and yellows with cool sky painted through the openings
of the branches for contrast. The strong, leaning trees create a series of triangular shapes.
The windblown horseman was added to accentuate the feeling of wind.

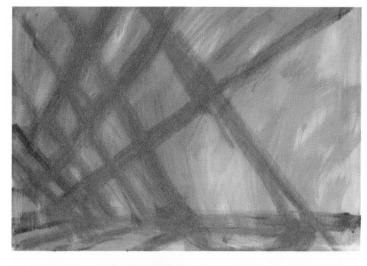

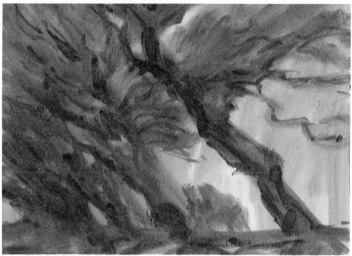

The strong diagonal pattern of lines divides the space into triangles.

Filling in the darks of the trunk and foliage confirms the triangular compositional shapes.

Adding color to the trees and sky creates the mood. Strong contrasts add drama.

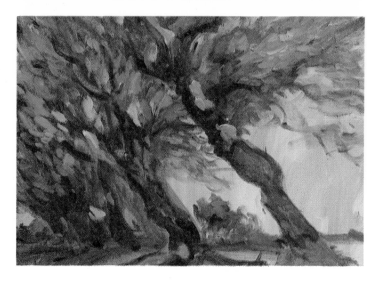

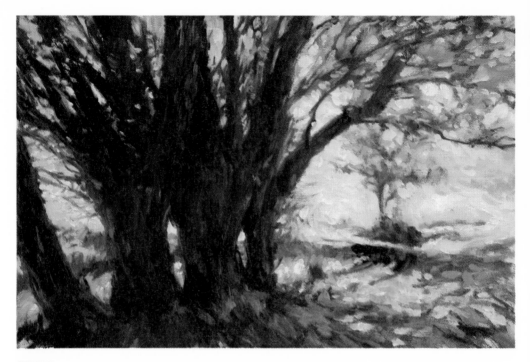

Willows

CONVERGING LINES

The pattern of this painting is quite obvious, done simply with the usual dark (Ultramarine Blue and Burnt Sienna) on the middle tone underpainting ground. It is not drawn as a tree, but as a fanning shape of tones and lines.

The intricasies of the twigs and branches were formed by the negative spots of light colors of the background. The back lighting gives a strong feeling of sunlight, enhanced by the warm lights and cool shadows.

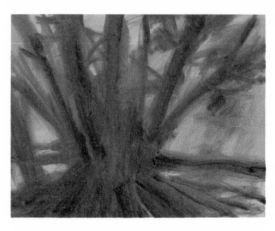

44

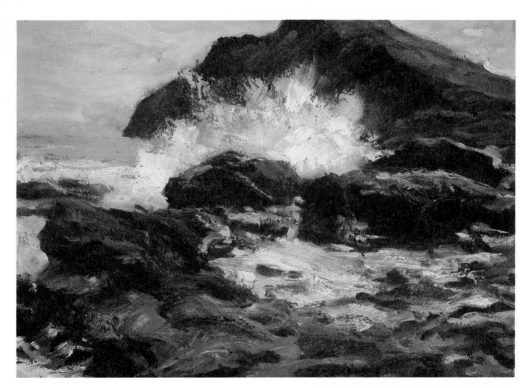

Oahu Surf

RHYTHMIC PATTERNS

This is a good example of how simple a pattern can be, and how it can contribute to a feeling of organization in a painting. The movement and flow of the water is enhanced by the rhythmic flow of the pattern itself. The black volcanic rocks create a strong contrast to the breaking waves and the pools, adding to the drama.

The "S" shaped pattern was put on the toned canvas with a paper towel, using a wash of Ultramarine Blue and Burnt Sienna. The blue predominates to make a cool dark.

Colors were added in the sky, the ocean and the pools. Also, variations of warm and cool colors were introduced into the darks of the rock and the distant headland for interest. A palette knife was used in many areas for texture and special effects.

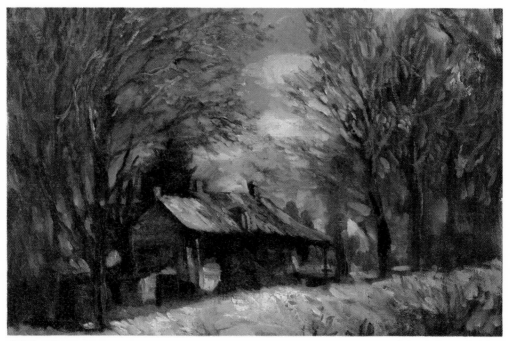

Old Homestead

PATTERNS AND SHAPES

This painting shows simple toning of the main masses in dark middle tone, looking for shapes, including the negative shape of the sky. Dark accents are added for shadow areas and some directional characteristics of the branches.

Color is important here to suggest the sun breaking through the rather stormy sky. The openness of the tree forms created by the sky coming through from the back, and strong lights, darks and warm colors on the branches are important. The strong yellow light on the foreground and the corner of the house forms the center of interest.

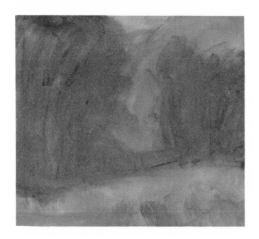

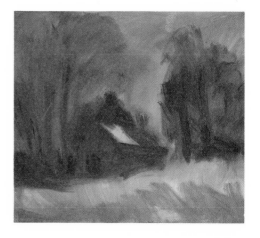

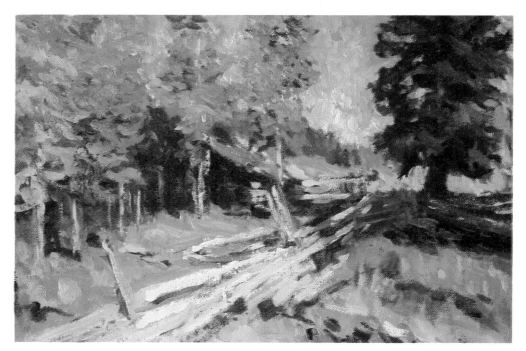

Boone's Cabin

I have escorted a couple of groups of students to this spot in Utah where the TV series "Daniel Boone" was filmed. It has the interesting characteristics of a sort of ghost town.

The pattern of this painting was applied with a paper towel as usual. It starts in the dark grass area (lower right), advances up the fence to the fir tree, then through all the shadows and tree shapes to the left side, making a rough "Z" composition. The dark accents are added next, and include the fir tree, its shadow, the shadows on the cabin and the other trees, and the darks of the fence.

Rough in the color in the shapes of the grass on both sides of the fence and the color of the background hills. Put in the lightest lights: the fence, the sky, and the lights on the cabin; to complete your value range. Play with colors to express the quality of sunlight on the aspens (warm greens and yellows) and put rich variations of warm and cool colors in the shadows.

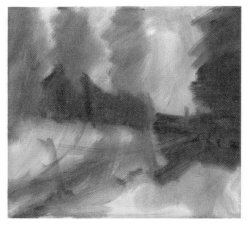

47

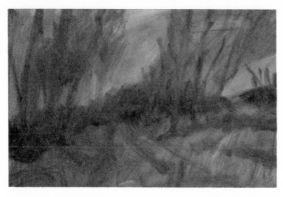

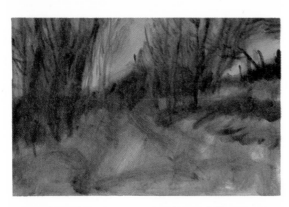

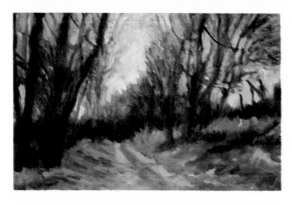

The basic rhythmic patterns are applied with the paper towel.

Dark accents and the development of forms on the hillside are added.

The addition of simple color shapes.

Further development of texture and color activity and negative painting of the sky.

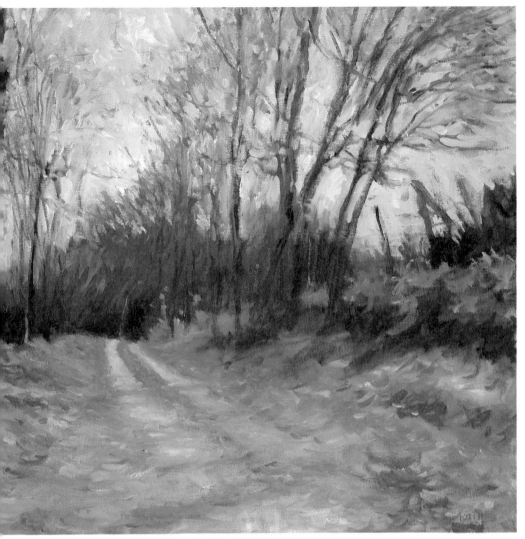

Connecticut Country Road

PATTERNS AND SHAPES

I find the painting of roads endlessly intriguing. The road leads you into the picture, toward the mysteries of the distant background. The nostalgia of the fallen leaves and the empty road becomes the mood of this picture.

The pattern is developed with an awareness of the movement of the forms toward the right. The tree forms are seen as silhouettes against the sky, even though the branches are bare. The curved radiating lines in the foreground establish the direction of the road and the hilly bank on either side.

Color is added: orange and yellow on the fallen leaves, red in the background trees and the roadside bushes, and pinkish-gray in the road. As you paint the sky, the tree branches will be developed in the negative by painting the openings through the trees, and around the twigs and branches.

PAINTING UPSIDE DOWN

Observing and painting non-objective shapes and relationships, rather than putting the emphasis on the objects themselves, is a completely valid idea and much simpler than drawing and painting things. Many times I have students turn their photographic copy around and make a painting upside down.

With the recognition of the subject minimized in this way, the patterns and shapes become very obvious and the continuity of lines and directional systems of perspective seem to leap right out at you. The rhythmic patterns that unify very complicated subjects (such as crowds of people or boats in a harbor) become obvious immediately.

I highly recommend that you do this a number of times, just as an exercise, to convince yourself that it really works. It is fun, and if you like, it can be carried to a higher degree of

This is the original photo turned upside down. The rhythmic patterns are very simple and obvious, without the distractions of recognizable subject matter.

On the toned underpainting, the pattern, in its simplest form, is put on the canvas with a wash of Burnt Sienna and Ultramarine Blue, using a paper towel swab.

finish, including some details and textures. Just be sure to watch the relationships and shapes carefully.

Do this one first yourself, as all the steps are laid out for you, and in this subject, are quite simple and the pattern obvious. Also notice there are no serious changes between the first and last steps. Each step leads directly to the next and everything put down at each stage leads logically to the next and contributes to the final result. There is no altering or backing-off of either values or shapes.

After you have completed this exercise, you can do any of the other step-by-step examples in this book by simply turning the book upside down and painting the steps in sequence, referring to the completed example as you progress.

You need to relate to the shapes abstractly without trying to figure out, for instance, what a house or boat or any other object looks like upside down.

After getting all the benefit you can from the examples in this book, you might try doing the same from photos of your own or clippings of choice subjects. You will soon be familiar with the concept and will find it much easier to discover the patterns and shapes in any subject, including those from nature on location.

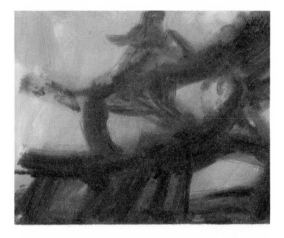

Dark accents, carefully studied for shape and size, using a richer mixture of the same colors, are applied to the pattern with a paper towel or a brush.

Simplified shapes of the principal areas of color are added. The paper towel is used in the larger areas, use a brush if needed. There should be no concern with details at this point.

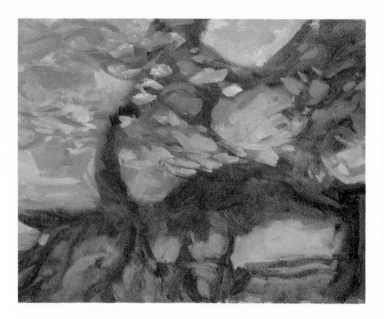

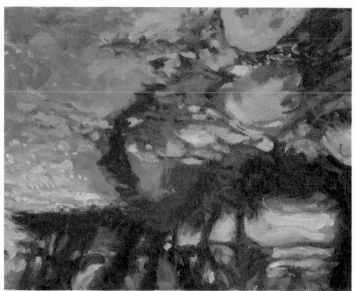

The lightest areas are now added to establish the complete value range.
The use of the brush is necessary here and in the final stages.

Textures and negative painting are called for here to create interesting edges.
Also needed is the development of some details and small accents.
Variations of tone and color are added for interest.

Now comes the fun part...the revelation...the unveiling...we turn it over! After a moment of admiring what
we have done and examining how clever we are, we get to work and complete the necessary refinements:
the final development of the figure, the addition of some flowers in the meadow, and whatever else seems
appropriate.

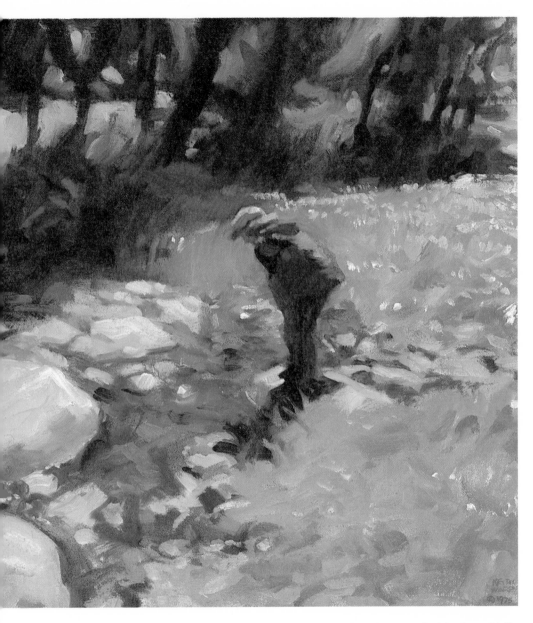

Sometimes new students come into my class and tell me that they are "white knuckle" painters, and that they usually take a couple of months to complete a painting. They use a three bristle brush to do each small detail, and every leaf and blade of grass is meticulously completed before moving on to another. It is hard work and production is painfully slow.

After watching my demonstration of this procedure, they start with their subject upside down. During one class session they complete a very creditable, impressionistic interpretation of their subject. It is simplified, unified and glorified by the use of a paper towel to start and large brushes to finish. It is done vigorously and freely, and has a happy and satisfactory development.

STEP-BY-STEP–Floral Still Life

Step 1: In this classroom demonstration, the painting is started on the toned canvas by roughing in the dark pattern of the background, the vase, and the red tablecloth, going around the ovals of the bouquet and the bowl of apples.

Step 2: Next, follow with some dark accents and the general yellow color of flowers and fruit.

Step 3: The bouquet is always thought of as a mass – never individual flowers. Add details in the apples, always trying to maintain their integrity as a group (as with the flowers).

Step 4: Further develop form in the flowers, the vase, and other objects.

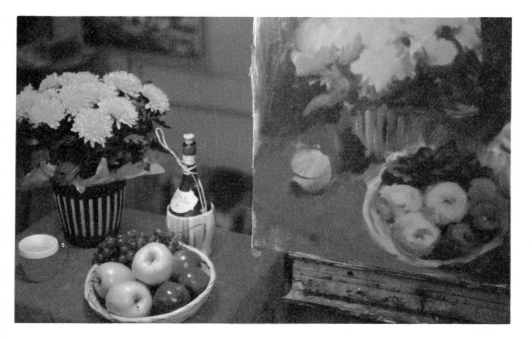

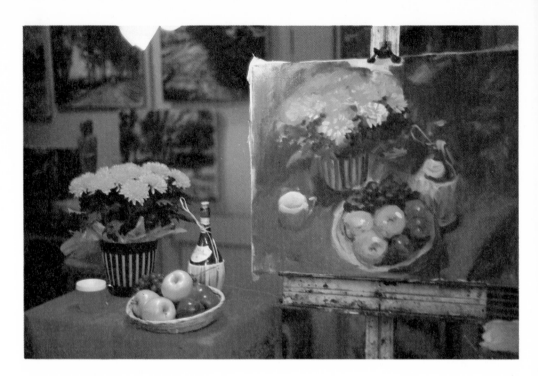

Step 5: Add highlights and light petals to enhance the forms. The increased detail and greater contrast bring the near flower forward, while the minimal details (darker value and soft edges at the top) cause the back of the bouquet to merge with the background and recede into it. The wine bottle is in middle values and with less contrast, doesn't detract from the main elements.

STEP-BY-STEP—Portrait

Painting a portrait is basically not any different than other subjects. Your first observations are the same. Look for the directional lines of the movement of the pose. Develop through the rhythmic patterns of tones. Observe the simple, big movements and shapes. Note the important relationship of the direction and shape of the folds of the garments to create an understanding of the unity, form and movement of the figure underneath.

Never start looking for a likeness of the features until all the big shapes, movements and relationships are established. The entire figure, attitude, and characteristic actions are part of the likeness; not just the conformation of the features.

As the painting develops, all the things that pertain to your growing understanding of the depth and beauty of the person are going to work together to create not just an accurate physical likeness; but a sense of the joy, the depth, and the nobility of the person.

It is difficult to accomplish this when working from a photograph as the camera is non-selective and non-analytical of these qualities. You can't always get that interpersonal reaction the way you do in the presence of a model.

Step 1: Using a paper towel, make the non-descript background underpainting of Raw Sienna and Cerulean Blue. Then, still using the paper towel and a warm middle tone wash of Burnt Sienna and Cerulean Blue (these colors are not arbitrary and may be different from one subject to the other as needed), establish the flowing movement of the entire figure in the space.

Be aware of the negative spaces such as the triangle in the upper left corner, from the elbow to the top of the head. Adjoining that is another triangle from the elbow to the center of the shirt to the apex at the top of the head. There is another from the lower left of the right elbow across the belt. The continuity of the shadow which includes the left side of the head, down the back of the hand to the left elbow, includes the shoulder and the back of the chair as one shape.

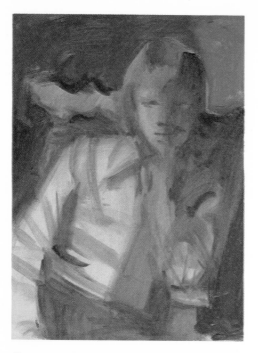 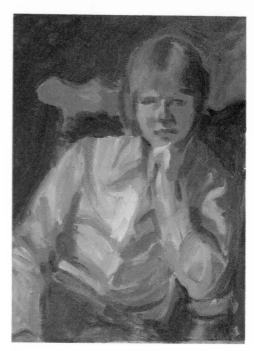

Step 2: Add the shades of the principal dark accents using the Burnt Sienna and Ultramarine Blue wash and the paper towel.

Step 3: Add a few more selective accents, including locating the features, using a #8 or #10 brush. Also, add a rough indication of the background color with the same brush.

Step 4: Add color to the face and shirt. All of these are variations of Cadmium Red Light, Yellow Ochre, and Cerulean Blue with white, as required. The shadows are cool so they have a lot more of the blue. The lights are warm so are mostly Cadmium Red, Yellow Ochre, and white. A touch of the blue is added here and there, where needed, to grey it down a bit.

Apply a rough indication of the color of the lips and the shadow of the turn of the cheek on the light side. A clean pinkish-red in the shadow on the cheek gives a hint of warmth to the entire cheek. A cool shadow in this area sometimes makes the face seem too cold and lacking the warmth of youth.

Step 5: In this step we paint the necessary details and adjust the values. This subject was for a class demonstration. The model was a girl dressed as a boy. Red-haired people often have a cool complexion as this girl did, and need just a hint of blue in the flesh tones.

Be careful with the use of white. Use only sparingly in a mix when absolutely necessary. Too much will wash-out the color and give a ghostly effect. If possible, raise the value of a pigment by adding a lighter pigment. For example, when using lighter Alizarin Crimson with Cadmium Red Light, the Cad. Red can be lightened with Cad. Yellow. White added to reds turn them pink and you lose the tone.

Lighten your greens, when possible, with yellow and lighten Ultramarine Blue with Cerulean. This is not a rule, as there will be times when it will be necessary to use white with all these colors, but it is a valid idea to maintain the impact and

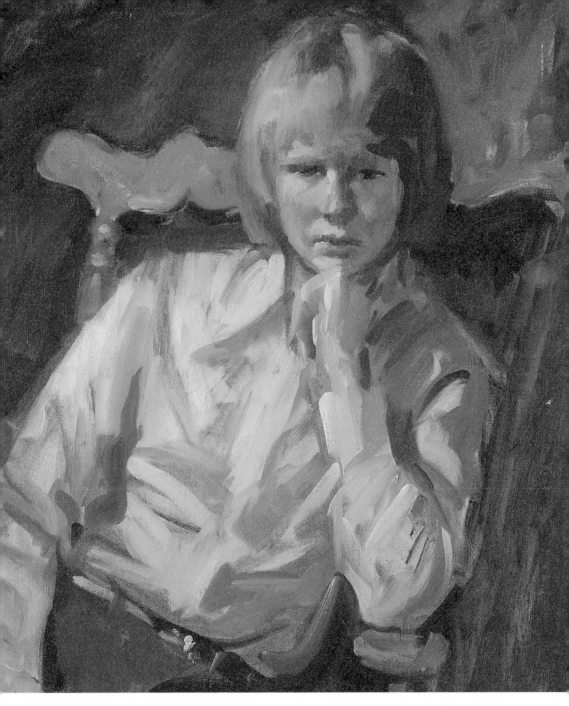

intensity of your colors as long as possible.

Avoid using colors other than the three primary colors (red, yellow and blue) to create your flesh tones. The flesh colors will be different from one subject to another, but variations of the three primaries will give an infinite variety without making any muddy colors.

Variations from cool to warm can be introduced impressionistically or pointallistically without mixing or smoothing to create the illusion of a living, breathing face.

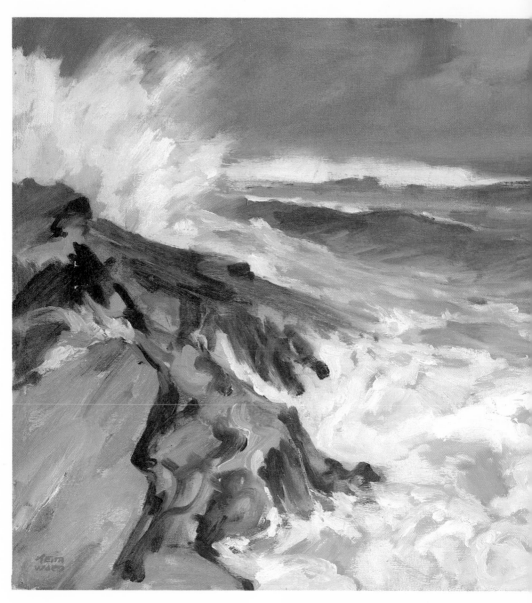

ROCKS AND SEA

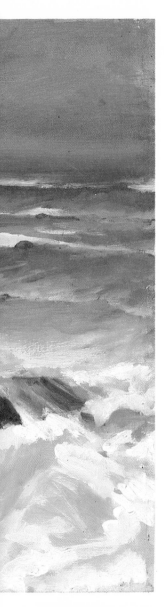

There is a lot of pleasure and satisfaction in painting seascapes. As with any other subject, the more familiarity and knowledge you have, the more understanding and feeling you can put into your interpretation of it.

Spend all the time you can at the ocean; walk the beaches, sit on the rocks, study the conformations of the waves under different conditions. You will notice that there is a constantly repeated pattern of the waves interacting with each type of shore; yet there is infinite variety, as it never repeats in exactly the same way twice.

The water reacts in a certain way with a rocky beach, and in another way on a sandy shore. It swirls around rocks in deep pools, and comes boiling back to the surface, mixing in a lot of air, appearing more opaque and lighter in color. It changes with the time of day, the tide, the weather, and what is happening far out at sea.

The character of the shore changes from one place to another. There will be light sandstone cliffs in one area and dark rocky headlands in another. The rocks are one color when they are dry, and darker when they are wet, and the same with the sand.

The structure of this painting is based on the triangular shape of the rocky ledge which is blocked in on the toned canvas with a dark wash.

The perspective of the waves in the background is created by lines radiating from a vanishing point at the top of the rock. The sky is rectangular.

Color is added, mostly warm on the rocks and cool greens and blues in the water. The white of the waves and foam is warmed with a bit of Yellow Ochre.

The dark stormy sky creates the lively mood, along with the details of the crashing wave. Brush strokes follow the flow and movement of the water.

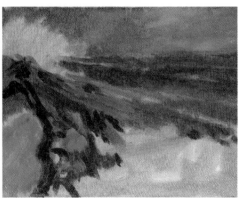

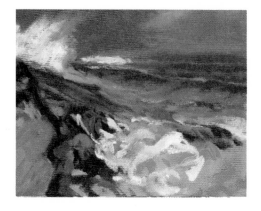

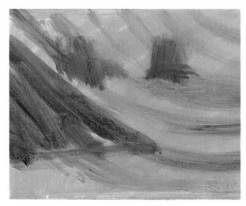

AFTER THE STORM

The patterns of this painting are based on a structure of concentric curved lines that radiate out from the point of the light source, in the upper right corner. These lines are marked on the toned canvas with a wash of Burnt Sienna neutralized with Ultramarine Blue.

The simplest shapes of the dark masses: the cliff, the distant rock, and the main wave pattern, are then put on the line pattern with the same tone, using the paper towel.

On this pattern of large shapes, apply the shapes of the dark accents, mainly on the rocks and the waves in the foreground. Most of this area is in shadow against the light so all of the values are relatively dark, even the foam and the waves. This unifies the foreground by (visually) making it one simple area.

Up to this point the composition has a very cool look. The suggestion is that the storm is over and the late sun has broken through, giving the whole picture a warm glow. So, now put in the warm lights on the cliffs, and the pinks and lavenders in the sky. Even though the waves are still running high and the foreground is under a cloud, it has a cheerful aspect.

In the finishing details, put the rocky island into the distance by softening and raising the value a bit to make it misty. Make the waves and foam dance and flow by having your brush strokes follow the direction of the movement.

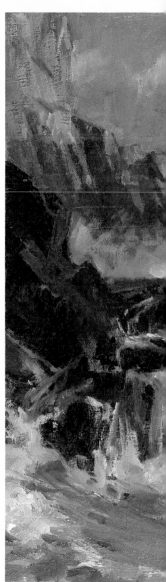

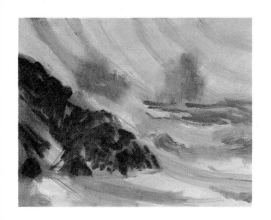
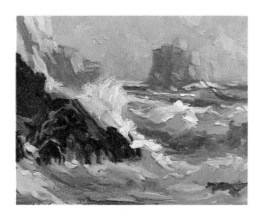
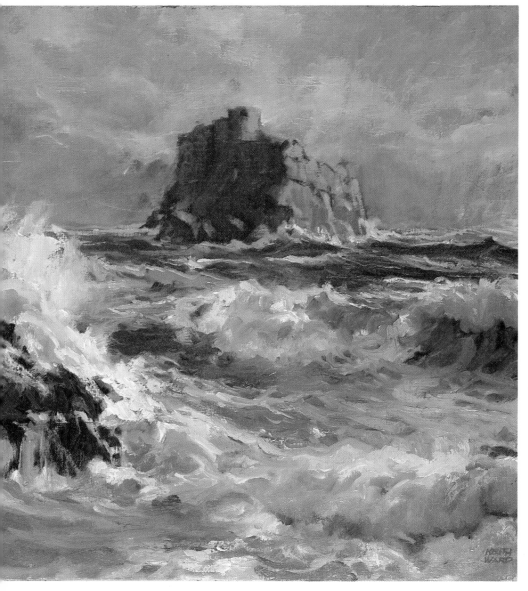

CREATIVITY

There is no one particular way to express ideas and emotions with paint, so the path is always open to explore and to experience the excitement of discovery. Find new ways of combining pigments on the palette to see how they interact on the painting to create interesting vibrations.

Explore the infinite possibilities of variety in shapes, rhythms, and patterns of the elements in your picture. There is infinite variety in nature, so in order to make things appear to be true to nature, studiously avoid repetition in shapes and spaces between objects.

In the beginning, people are inclined to feel that if something is good, then more of the same is better. This is definitely not the case. Variety of brush strokes, varied patterns and shapes, variety of color relations, inventive tonal relationships, and variety in subject matter lead to a wide range of view points, mood and interpretation.

Many times an artist will get caught up in the trap of commercial success and public acceptance of a certain theme or style of subject and repeat a formula over and over. They reach a plateau, then find it difficult to break away for fear of breaking the "magic" formula.

Success and acceptance are certainly gratifying but artistic growth is even more so. The stimulation of learning and finding new ways of expressing yourself will make your work continually fresh and exciting to your viewers as well as to yourself.

Keep surprising yourself and sometimes fascinating things will happen in the development of a painting that will startle and amaze you. Sometimes you get the feeling that things are happening of themselves, outside your own volition, and give you a thrill of creative accomplishment that will be its own reward.